Sketchbook DARES

24 WAYS TO DRAW OUT YOUR INNER ARTIST

Laura Lee Gulledge

ABRAMS, New York

DEDICATED TO MY TEACHERS
Especially my high school history teacher, Linda Young, who taught me to question *everything*.

Designer: Celina Carvalho

ISBN: 978-1-4197-2606-4

© 2017 Laura Lee Gulledge

Printed and bound in China
10 9 8 7 6 5 4 3 2 1

Abrams Noterie products are available at special discounts when purchased in quantity for premiums and promotions as well as fundraising or educational use. Special editions can also be created to specification. For details, contact specialsales@abramsbooks.com or the address below.

ABRAMS The Art of Books
195 Broadway, New York, NY 10007
abramsbooks.com

"When I dare to be powerful, to use my strength in the service of my vision, then it becomes less and less important whether I am afraid."

—Audre Lorde

Welcome!

DO YOU FEEL CREATIVELY CURIOUS?

DO YOU CRAVE AN OUTLET FOR EXPRESSION?

DO YOU LOVE TO DRAW AND TELL STORIES?

DO YOU WANT TO ADD NEW TOOLS TO YOUR ARTISTIC TOOLBOX?

If you answered YES to any of those questions, then this book is for you! You don't need to be an experienced artist to enjoy and benefit from this two-dimensional adventure. These dares are for people of all backgrounds and ability levels . . . all you need is a dash of DARING.

Why did I make this book?

I used to be really shy, afraid of taking risks and afraid of failure. I felt unworthy and crazy and over-whelmed by my own thoughts. But then . . . I started working seriously in a sketchbook. And it SAVED MY LIFE. How? By daring me to actually live it.

Filling in each blank page of my sketchbook was like accepting a little dare: to make a mark, have a point of view, crack a joke, ask a question, feel things deeply, try something new, go out on a limb, share a story, take a risk, and grow past my limitations.

In the beginning, I was admittedly intimidated by the "blank page." But with each drawing I got a little braver . . . a little stronger . . . a little more daring. Ultimately that courage spilled over into my real life, allowing me to attempt the greatest dare of all: becoming myself.

I believe everyone deserves access to the transformative power of creative expression, and it all starts with a single blank page. Are you daring enough to fill it?

What are the dares?

These are my favorite art activities that I have collected over the past 15 years; most of them I developed as my own personal form of art therapy. Some were inspired by my sketchbook practice, my art classroom, and my dear Artners* and mentors. And some are brand spankin' new for this book!

*An ARTNER is a partner in art, a creatively supportive friend or collaborator.

Dares are designed to:

Clear
- the cobwebs between your head and hands.
- your perception of yourself and the world around you.

Practice
- drawing from reality, your Mind's Eye, and X-Ray eyes.
- reflection, critical thinking skills, and taking risks.

Learn
- how to overcome obstacles and creative hang-ups.
- how to tap into inspiration and express emotions.

Explore
- different ways of organizing and filtering ideas.
- visual storytelling using both words and images.

Strengthen
- your focus, flexibility, and follow-through.
- your support system and build creative confidence.

How do they work?

These 24 dares are designed to develop a well-rounded artist by developing the hands, heart, mind, and spirit. All four parts are a needed in the creative process, which I think of as a cycle that mimics the Medicine Wheel. A quarter of the dares in this book will cultivate each of these needs:

Connecting to the larger world, making your individual experiences universal, and fulfilling your purpose.

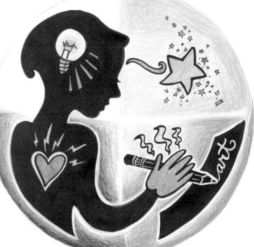

Spirit

Activating your intellect, exercising your imagination, and practicing mental visualization.

Head

Hands

Reactivating physical dexterity, exercising production skills, and training hands to follow your intentions.

Expressing emotions, reflecting on experiences, making work more personal, and listening to intuition.

Heart

After each completed project you start the cycle all over again! Make sure you keep moving—it can easy for us to get stuck in one part of the cycle. If you do get stuck, explore the opposite area on the wheel.

How do I use this book?
...in five easy steps.

1. Decide your company.

You can complete these dares by yourself, with your class, or with an Artner.

2. Make time.

I would recommend completing two dares a week (making this book a three month commitment) and giving yourself two to three hours of time to complete each dare. Here's a sample breakdown of how I typically will spend a three-hour work session:

→

20 min Puttering & thinking
10 min Setting up
15 min Brainstorming
20 min Pencil sketching
90 min Making the final artwork!
15 min Break (when needed)
10 min Cleaning up
=180 minutes total

3. Make space.

Clear an organized workspace where you can think and be productive. Decorate it with things that will inspire you. Stock it with fun art supplies to play with. Post a sign with your weekly "Working Hours."

4. Share your journey.

Talk to your friends, family, and mentors about what you are doing! Show them your drawings! By sharing your dream with them, they can help provide support . . . and help hold you accountable.

5. Do what works for you.

Work at your own pace and figure out what system works best for you! Dares are designed to be completed in order, but feel free to hop around and follow your inspiration!

What supplies do I need?

THESE ARE THE BASIC MATERIALS USED FOR COMPLETING THIS SKETCHBOOK:

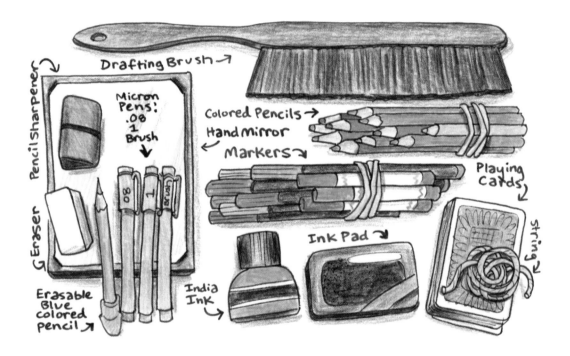

Pencil Sharpener
Drafting Brush →
Micron Pens! .08 1 Brush ↓
Colored Pencils →
Hand mirror
← Markers ↘
Playing cards
Eraser
string
Erasable Blue colored pencil ↗
India Ink ↘
Ink Pad ↘

Art Supply Tips:

- Try to avoid smudgey materials like graphite pencils, chalk pastels, and charcoal.
- Be mindful of materials that will bleed thru the pages, such as permanent markers.
- If you use paint, use rags instead of paper towels for blotting.
- If you get tired of waiting for a layer to dry, use a hair dryer to dry it in a flash!
- Feel free to alter the pages by cutting them, sewing, or incorporating collage.

Let's get started!

Sometimes it can be hard to begin a new drawing or creative routine. These are the steps I use to help overcome "Blank Page Syndrome."

Permission to Putter

Give yourself time before going to your desk to take care of possibly distracting tasks (chores) or thoughts (journaling) or physical needs (eating).

..

Set the table

Lay out your art supplies and set up your work station. Tidy up an put away other projects. Mix up the colors of paint you want to use. Sharpen the pencils.

..

Opening ritual

Establish your own routine for how you get started. For me it's making something yummy to drink and picking the perfect music to listen to.

..

Activate the page

Break the "blank page" seal by sketching out a light border or boundary marking the space your drawing will occupy. That shape becomes your magic door.

..

Don't look back

When you start drawing don't stop for a second to judge, edit, or nit-pick what you're doing. Put on blinders and go. You can worry about whether it's good later. Let yourself make a mess.

..

Commit yourself

I find the best way to ensure success is to make a clear commitment to achieving my goals: by putting my intentions in writing! (*See next page*)

Creative Contract

I, .. (name) hereby accept this Sketchbook Dare challenge.

The day or time that I'm designating as "sketchbook time" each week will be

.. and/or ..

My goal for finishing this book is .. (ideal date) but if it ends up being more

like ... (back-up date) that's okay, too.

My reward for completing all 24 dares will be ...

which I promise to give myself in recognition of my hard work and commitment.

If I feel like giving up, I will reach out to ... (friend/family member) or

.. (teacher/mentor) to give me inspiration and encouragement

to keep going.

By signing this contract I promise to:

- Do my best, be honest, and have fun.
- Relish my successes and see my mistakes as opportunities for learning.
- Keep an open mind, be willing to try new things, and trust my instincts.
- Treat myself and my efforts with kindness rather than judgment.

Laura Lee

YOUR SIGNATURE

YOUR NEW ARTNER

Don't worry, I'll be drawing right alongside you! So you won't be alone on this journey.

For your first challenge...

I DARE you to open this book to a random page in the middle!
Write a nice note to your future self on that
page to be discovered another time. You'll thank you later.

Doodle Dare

When I'm getting warmed-up to start a new
creative practice, I will often use an art activity
that I loved as a kid: doodling!

Such activities shake off the cobwebs
because they awaken muscle memory and rekindle
our passion for using our hands.

I DARE YOU TO DIP YOURSELF IN DOODLES!

Every sketchbook should open with a portrait of the artist! You will draw one to be embellished with doodle patterns.

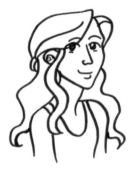

Draw yourself from memory, not a mirror. Present who you are right now in this moment. Keep it simple.

Draw shapes framing your portrait: one in front of you and one behind you. Shapes could be geometric, organic, etc.

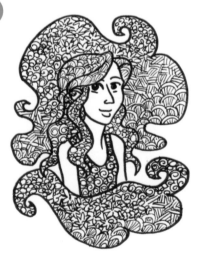

Doodle designs inside everything but the skin. Perhaps focus on one pattern or include multiple designs.

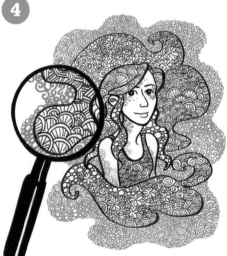

Add small doodle accents on your skin. Done! You can also fill in the background with more doodles if you wish.

TIP *Play with pen size! Try a big-size marker to draw the portrait and framing shapes . . . a medium-size marker for the main doodles . . . and a small-size marker for the skin doodles.*

I DOUBLE DARE YOU TO DOODLE TWO-HANDED!

Jolt your hands awake with ambidexterity—drawing with both hands at once!
Make wavy lines and doodles down the page, mirroring each other symmetrically.
Note: Your nondominant hand might draw terribly! So don't judge it too harshly.

"A drawing is simply a Line going for a walk."

-Paul Klee

"What did you do as a child that made the hours pass like minutes? Herein lies the key to your earthly pursuits."
—Carl Jung

Mapmaker Dare

Let's get grounded in your surroundings before branching out in new creative directions. Connect with your space by mapping it!

Drawing real-world data stimulates your logical side. It's a good warm-up for getting your hands and head to work together.

I DARE YOU TO MAP OUT A HOME!

Draw a map of your home. This could be your neighborhood, town, region, country, continent, planet, or galaxy. It could be where you live now, where you used to live, or where you wish to live in the future.

Find an existing map of your home that you want to copy from. Draw a border on the map marking the section of it that you will focus on. Then start drawing! Start with the main roads and boundaries. Work with pencil at first.

Add landmarks and label all the places, roads, and natural sights using marker. Feel free to personalize it. Mark where you and others live. Add map title and a compass rose, if you desire. Color in background with colored pencil.

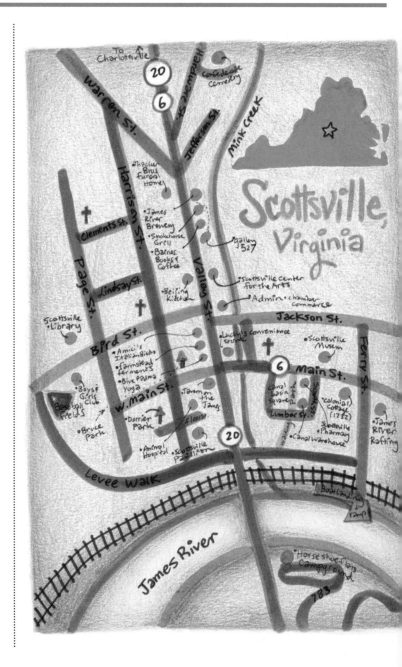

TIP *I tend to draw maps twice. First, I will do a sketch to get to know the place and understand how all the parts are connected. Then I will do the final drawing, and it's a lot easier. Also, try to keep the tiny writing legible when labeling things!*

I DOUBLE DARE YOU TO MAP WITH SOUND!

Make a word art image that recreates a place where you spend time: home, classroom, workplace, hangout, etc. Close your eyes and listen to all the sounds, both natural and manmade. Make a list, then use the words to create a visual composition.

"Anytime I feel **lost**, I pull out a *map* and stare. I **stare** until I have reminded myself that *life* is a giant **adventure**." So much to do, to see.

— Angelina Jolie

"The man who goes up in a balloon does not feel as if he were ascending, he only sees the earth sinking deeper below him." —Arthur Schopenhaur

Copycat Dare

One of artists' favorite tricks is to play with reality.
You begin by copying reality, recreating it,
and then you can play tricks with it.

When drawing realistically, you're moving visual data
from one place (the subject) to another (your paper). So the
more two-dimensional your subject is, the easier to copy!

I DARE YOU TO COPY REALITY!

Try out the *trompe l'oeil* art drawing style, which is French for "trick of the eye." It's a drawn copy so realistic it gives the illusion of being real.

Select a few flat mementos like ticket stubs, patches, stamps, etc. Tack each one down to your paper with a roll of tape on the back. Trace where the drawn ones will go.

 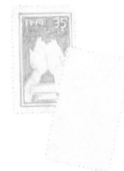

Shade in your objects with its base layer colors, building up thin layers of colored pencil shaded lightly in opposing directions.

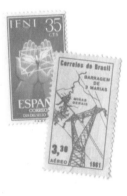 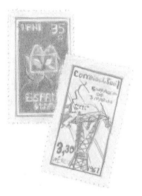

After the flat areas are shaded in, you can begin to add linework, lettering, and fine details with sharpened colored pencils.

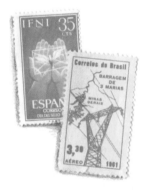 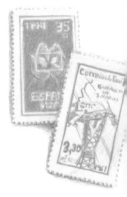

Don't forget to add imperfections! When done copying, add shadows on the underside of both the real and duplicate versions. The final touch!

I DOUBLE DARE YOU TO WRITE LINES!

Select a letter in your handwriting that you would like to write differently. Or your signature. Copy your new letters. Practice writing them. If you're still using it three months from now . . . you know your hands are truly trainable.

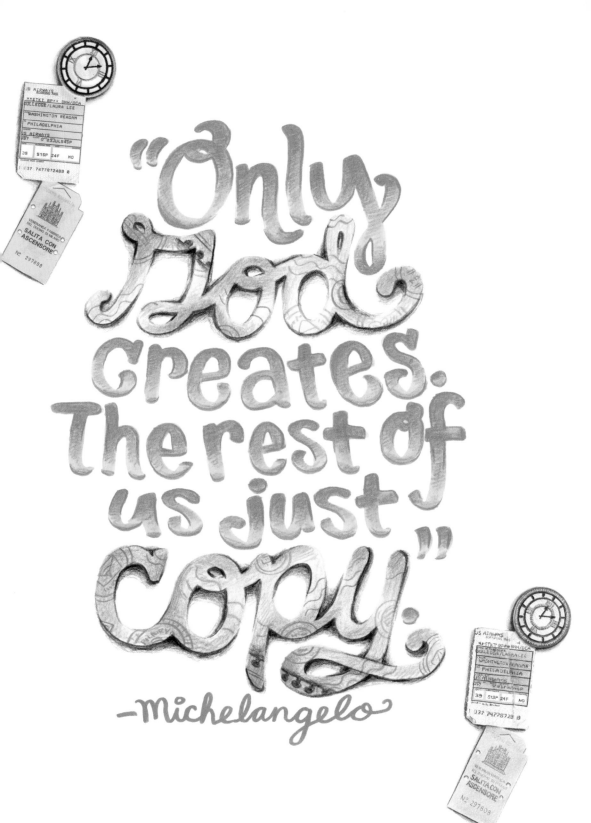

"Only God creates. The rest of us just copy."

—Michelangelo

"Start copying what you love. Copy copy copy copy. At the end of the copy you will find yourself."
—Yohji Yamamoto

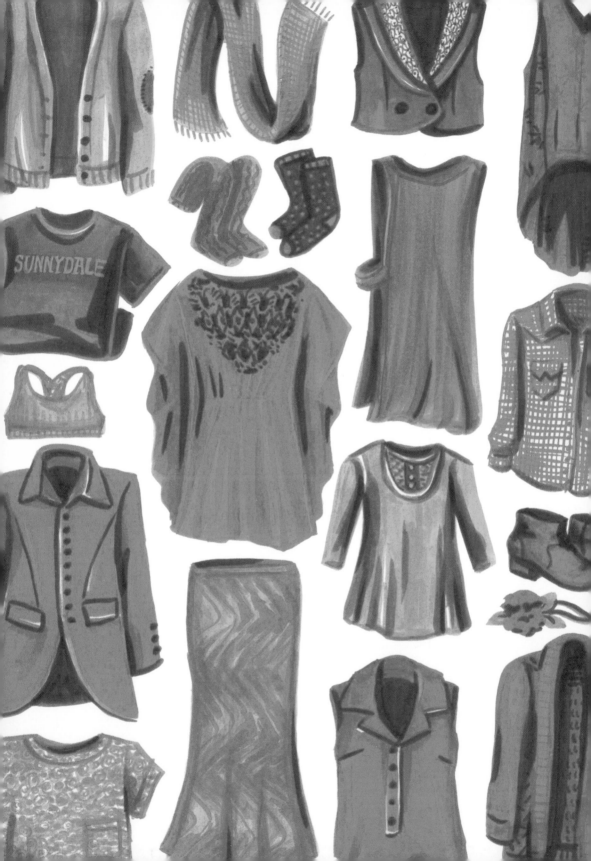

Dress Up Dare

Indecision can prevent us from getting started on projects, so pay attention to to your process for making decisions. Do you follow an instinct?

One simple opportunity to notice your intuition in action is to observe how you dress each morning. How do you pick who to "be" that day?

I DARE YOU TO DRESS A MOMENT!

Draw a portrait of a special outfit or a single piece of clothing that has personal significance to you. Perhaps something important or noteworthy happened in this outfit, it was a gift from a special person, or it reminds you of a happy time.

1 Lay the clothes out on your bed in a visually pleasing composition. Look at from above. Perhaps include accessories, shoes, bag, etc. Sketch with pencil, then shade or color in as desired! Have fun with the patterns and textures of the clothes.

2 Under your drawing, add a caption. Write one sentence or a few sentences about what happened in that outfit. You can get into detail or keep it general. Congrats, you've now combined words and pictures to tell a story! Aka: visual storytelling.

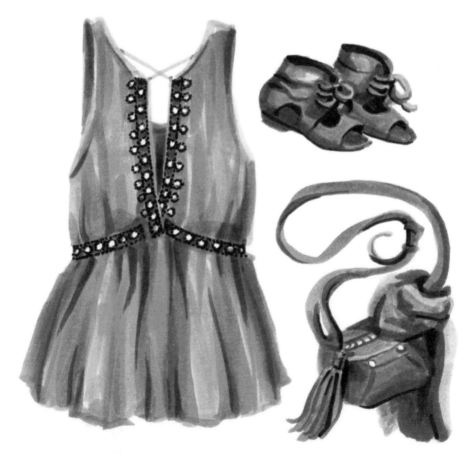

the day I fell in love with you

I DOUBLE DARE YOU TO DRESS YOURSELF!

Think about the different roles you play in your life at home, work, school, friend groups, clubs, etc. Draw these different sides of yourself as paper doll clothes for a paper doll version of yourself. You could also draw these roles as multiple hats instead.

"It's not about
the **dress**
you wear,
but it's about
the **life**
you lead
in the dress."

—Diana Vreeland

"The secret of getting ahead is getting started."
—Mark Twain

memory Dare

It's much harder to draw something from our heads than it is to copy from reality, because in order to draw from memory, you must first unlock visual data and then draw.

To do this we use our mind's eye, which allows us to access images from our past, future, imagination, nighttime dreams, and daydreams.

I DARE YOU TO DRAW WITH YOUR NOSE!

Smell is our strongest link to memory, so illustrate a memory that's inspired by a scent. Pick a scent you have access to, so you can smell it right now. It could be linked to a childhood memory or perhaps something more recent.

1

Smell your chosen scent and and close your eyes . . . picture the memory in your mind. When was this? Where were you? What were you doing? Was anyone else there? What objects were in the space? Were there sounds or textures?

2

Draw your scene in pencil, then go over with ink as a black-and-white line drawing. Then use spot color to illustrate your scent, making it a visual design. Finally, add a caption explaining the memory, along with a close-up sketch of the object.

The woody scent of Palo Santo, known as holy wood, always takes me back to Camp Ballibay and reminds me of my Artner Larken! She burned a stick of this in the room we shared while producing our first full production of the Will & Whit Musical.

TIP *If reconstructing a whole scene sounds too challenging, you can focus on illustrating a close-up of the part you do remember, draw more abstractly, or simply leave out the parts you're unsure of. Start with what's most clear and go from there.*

I DOUBLE DARE YOU TO SHARE A DREAM!

Illustrate an even more challenging memory: a scene from a dream. It could be a dream you've had recently, one from childhood, a reoccurring dream, a stand-alone nightmare, an experience of lucid dreaming, etc. Incorporate text explaining the dream.

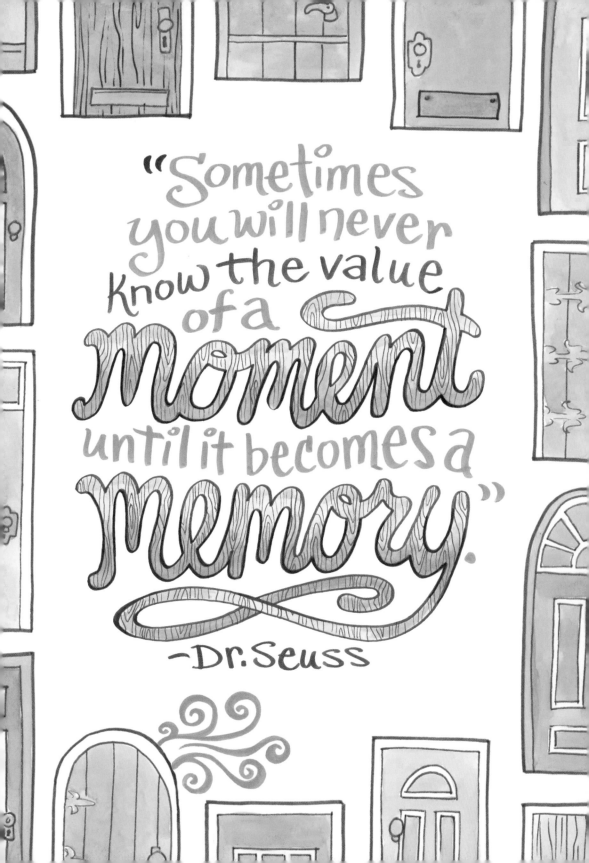

"Life is like a garden.
Perfect moments can be
had, but not preserved,
only in memory."
-Leonard Nemoy

**Artists filter reality through their style.
We do this three basic ways:**

Simplify: Show less visual data, boiling it down and taking away what's not essential.

Multiply: Show more visual data than what is visible from one viewpoint or point in time.

Stylize: Invent visual data to alter reality, usually inspired by a visual theme or mood.

I DARE YOU TO STYLIZE TREES!

Draw the same tree (or leaf) in three different abstract styles!
For this I recommend working from a photo rather than drawing from life.

1

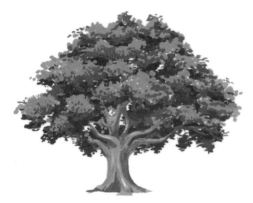

Choose your tree! First draw it once on the realistic side. Pay attention to how the branches and leaves grow out of the tree.

2

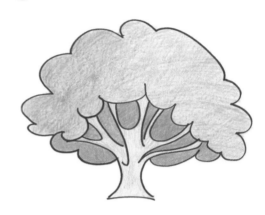

Now draw your tree using the Simplify filter. Squint your eyes to help you see the more "basic" forms that make up your tree.

3

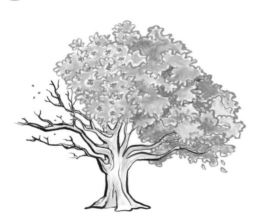

Draw your tree using the Multiply filter. How to show "more?" Show it over time, it's hidden layers, or multiple overlapping angles.

4

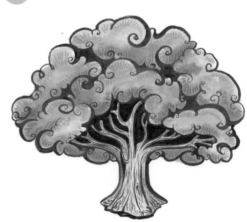

Finally, draw the tree using the Stylize filter. Find inspiration in a visual motif, color scheme, or mood to then "dip" your tree in.

I DOUBLE DARE YOU TO STYLIZE PHOTOS!

Draw or paint on top of a photograph or other printed image. Get whimsical and surreal with your own fictional additions! Add designs, props, and characters to alter the existing visual data, perhaps even creating a new story.

"In matters of style, swim with the current; in matters of principle, stand like a rock."

-Thomas Jefferson

"When you are an artist you can turn your hand into anything, in any style. Once you have the tools then all art forms are the same in the end."
—David Bowie

Double Vision Dare

See in double vision by using both sets of your eyes: your Naked Eye and your Mind's Eye!

Your Naked Eye transfers visual data from reality onto the paper. Your Mind's Eye is trickier, as it recreates what you see in your head.

I DARE YOU TO DO A DOUBLE TAKE!

Choose a personal or household item you use daily, like a hairbrush, alarm clock, house keys, coffeepot, pair of shoes, etc. Decide on your object when it is out of sight. Don't sneak a peek first!

1 Now draw your object in Double Vision: once from memory and once from reality. When drawing from memory, use your imagination to recreate it in your Mind's Eye so you can add as many details as possible. But do it FAST!

2 Lay out your drawings each on half of the page, horizontally or vertically. When you've completed both drawings, compare the two! What visual data was lost, invented, or emphasized in your memory drawing?

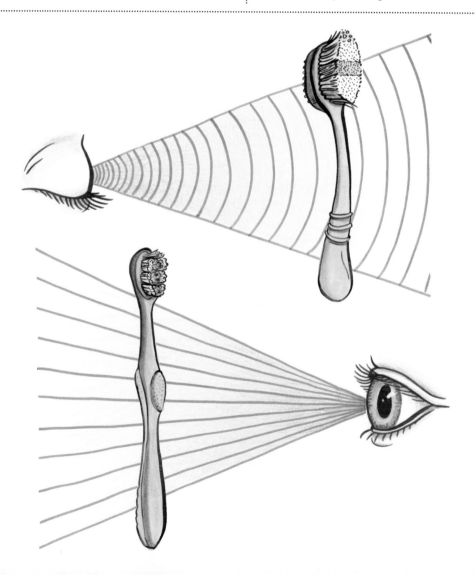

I DOUBLE DARE YOU TO LOSE YOUR VISION!

Make a Blind Contour Drawing of a pet or person from life.
Trace over every contour of their form with your Naked Eye as your hand follows
along on the paper. Keep your eye on your subject and keep your pen on the page!

"If *art* is to nourish the *roots* of our culture, society must set the artist *free* to follow his *visions* wherever it takes him."

~John F. Kennedy

"Don't worry how you 'should' draw it. Just draw it the way you see it."
—Tim Burton

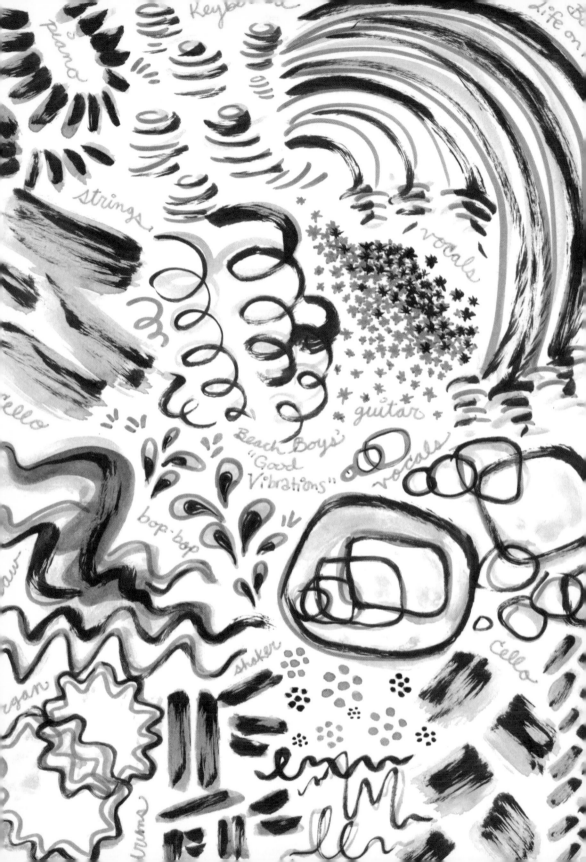

Music Dare

One of my favorite games to play in my Mind's Eye
is visualizing music, to allow sound to inspire movement
both in my head and in my hands.

Let your body move and hands draw with the music.
Do the sounds feel smooth or crunchy, still or swirling,
sliding or stomping, rising or falling?

I DARE YOU TO DRAW A SONG!

Choose a song that evokes a feeling, has an interesting sound, a good rhythm, and inspires movement. Pay attention to repeating sounds and patterns.

1

On a separate piece of paper, draw your visual word bank: an abstract line, shape, or pattern for each part of your song. Practice over multiple listens and pick your top three.

2

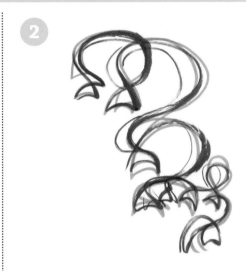

When you're ready to dive in, draw your first design going across the page!

3

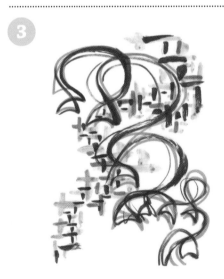

Draw your second design. You can draw across the page or just pop in one spot. Relax your breath and your body.

4

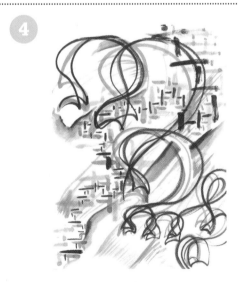

Finally, add the third design. Try to "complete" the composition. Perhaps even add a splash of another design from your word bank.

I DOUBLE DARE YOU TO DRAW AN ALBUM!

Pick a favorite album or single and redesign its album cover! Choose a design that captures the mood and style of the music visually. It could show the artist or not. Pay special attention to the lettering, neatly adding the title and artist to your cover.

"Music is the vapor of art."

—Victor Hugo

"Color is the keyboard,
the eyes are the harmonies,
the soul is the piano
with many strings."
-Wassily Kandinsky

Possibility Dared

Embracing possibility allows us to open up our minds and exercise our imaginations to see what is invisible to others by using our X-ray eyes.

Artists look deeper to see what's missing, overlooked, and could potentially be. Never underestimate the value of your interpretation of reality.

I DARE YOU TO SPOT POSSIBILITY!

You will practice spotting possibility by seeing the potential image within an image, then making that visible by illustrating what you see. Finding order in chaos is the ultimate test of your creative improvisational skills!

1 First you will make an abstract design, by dipping a string or piece of yarn in ink or thinned-down paint. You will drop your soaked string down onto the blank page. Then you will drag it, pull it, move it, swoop it across your page!

2 When it's dry, look at it from different angles. What do you see within the ink lines? Open your mind to possibility and see what ideas pop first in your head. Then complete the image with marker or pen, filling in the scene so we can see what you see.

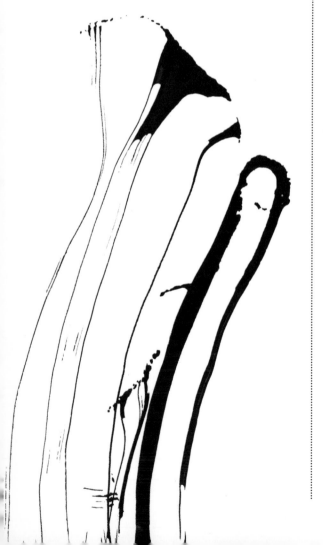

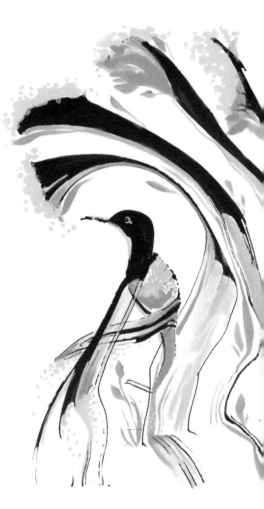

Allow yourself to try this string-dragging technique multiple times to get the hang of it. This will also give you more options of designs to choose from, ensuring one of them should tickle your imagination as an image to develop into a scene.

I DOUBLE DARE YOU TO SHARE A VISION!

On paper, anything is possible! Draw your vision for a "big crazy idea."
Perhaps it's an idea for a sculpture, building, film, product, installation, book,
fashion line, tattoo, garden, phone app, road trip, movement, community, anything!

"Without leaps of imagination, or dreaming, we lose the excitement of possibilities."

—Gloria Steinem

"The rock pile ceases to be a rock pile the moment a single man contemplates it, bearing within him the image of a cathedral."
—Antoine de Saint-Exupéry

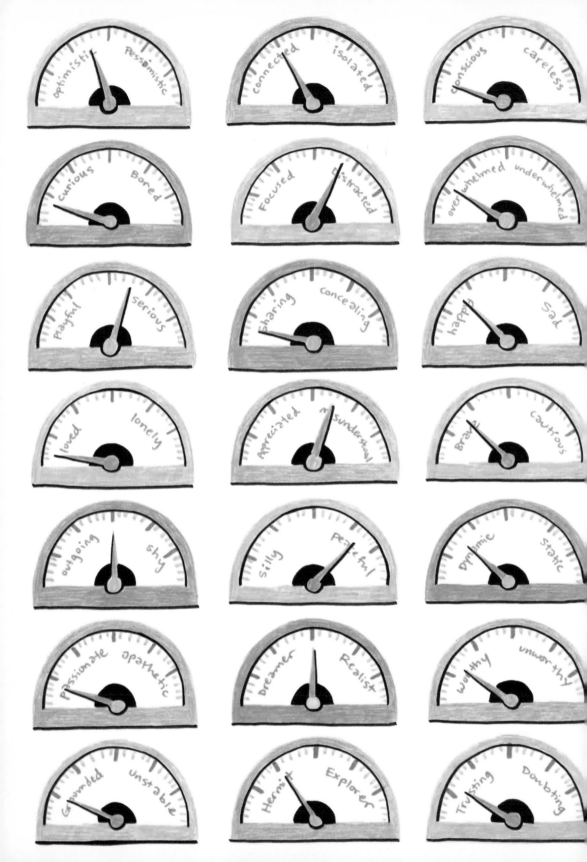

Feeling Dare

How are you feeling today? This simple, everyday question can always be a source of inspiration and a moment of reflection.

Look at yourself in the mirror of your Mind's Eye, seeing your honest and authentic self. What do you see reflected back?

I DARE YOU TO DRAW OUT A FEELING!

Create a self-portrait that illustrates a feeling, focusing on your eyes.
First, pick an emotion you've experienced recently. How have you been
feeling physically, emotionally, mentally, or spiritually?

1

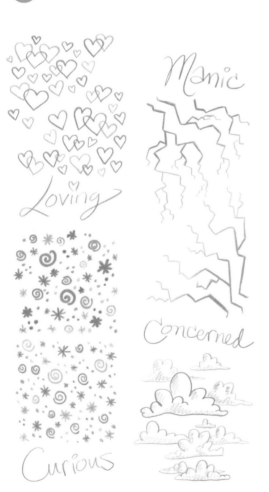

2

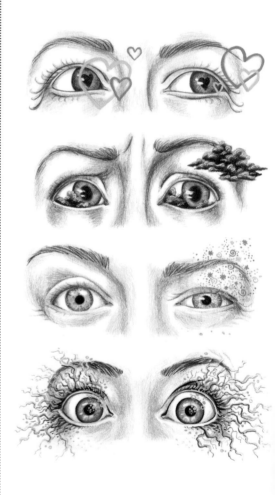

Brainstorm in words, pictures, designs, and symbols that express your feeling. Think about its position and movement. Is it coming out or going in, inside or outside you eyes? Are you looking away?

Draw out your eyes and eyebrows expressing your chosen emotion in brown colored pencil. Shade realistically. Then add extra designs that capture your feeling, perhaps with marker. Show us what you feel inside on the outside.

I DOUBLE DARE YOU TO DUMP FEELINGS!

Meditate silently for ten minutes. Then draw your head as a side-view silhouette. This is your container to fill with words! Fill it with the thoughts and feelings that popped up during your meditation. What's been clogging your head?

"Don't fight forces, use them."

— Buckminster Fuller

"A work of art
which did not
begin in emotion
is not art."
-Paul Cézanne

Da Vinci Dare

Leonardo da Vinci also loved working in sketchbooks!
In them he would make studies, play with perspective,
and draw objects in motion.

You will try out two of da Vinci's other favorite
drawing activities that kept his skills sharp: drawing
multiple points of view and drapery.

I DARE YOU TO STUDY LiKE DA ViNCi!

Look at a natural object up-close and in-depth like da Vinci. . .
by drawing it from multiple angles! Rotate it in your hand. Select something
more round than flat, ideally with an imperfection.

1 To lay out the page, I started by sketching out a six- or eight-slice pie shape aligned vertically. I then made a circle inside each slice for each individual drawing, and erased all the previous pencil lines.

2 When done capturing your object's different sides, look up the latin name/word for your natural object. Or whatever language of your choosing. Learn something new! Write it neatly in the center.

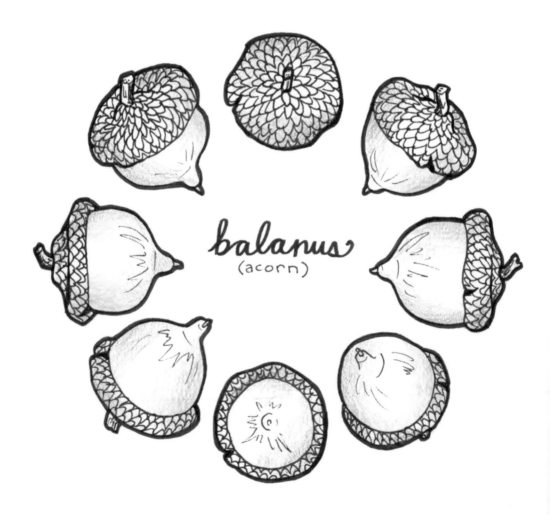

balanus
(acorn)

TIP *Focus on the lines and contours of your object rather than trying to capture its shading. Sketch it out in pencil and go over with a fine pen. Feel free to add color or other designs / decorations in the background.*

I DOUBLE DARE YOU TO FOCUS ON FOLDS!

Get lost in the folds . . . by drawing a close up of draped fabric!
Focus on the shading and lighting instead of drawing outlines.
This is an exercise in observation, duplicating shapes, and cultivating patience.

"*Learning* is the only thing the mind *never* exhausts, *never* fears, and *never* regrets."

—Leonardo da Vinci

"I am always doing what I cannot yet do in order to learn how to do it."
—Vincent van Gogh

Playing Card Dare

Like a deck of cards, we each contain many suits and many different aspects of our personality. Sometimes these sides oppose or contradict one another.

Reflecting on our own duality helps us better understand how we operate, how to find balance, and how to feel less like a "split" personality.

I DARE YOU TO PLAY YOUR HAND!

Draw the two sides of your personality as a single playing-card-inspired design. It could be your public versus private identity, your light and dark sides, the old and new you, etc.

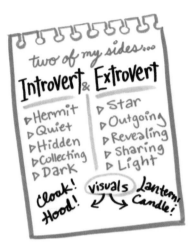

Brainstorm in words and pictures which duality about yourself you'd like to illustrate and how you could express it through an image.

Sketch the borders of your image, and draw a horizontal line or S curve to divide the composition in half in a way you like.

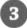

Draw your two sides, each on half of your composition, one right side up and the other upside down. Unify the two designs visually.

Add other designs and patterns. After drawing everything in pencil, lighten your pencil lines with an eraser and ink over all your lines.

TIP *Look at real playing cards for inspiration! This is a fun opportunity to play with existing patterns or make up your own. You can make it super flat and graphic or draw it in your regular art style. You can keep it black and white or incorporate color.*

I DOUBLE DARE YOU TO CUT THE DECK!

. . . literally! By making a collage out of a deck of playing cards. Ideally repurpose an old unplayable deck that is missing cards. Use the designs on the backs of the cards as your background pattern and the face cards to make a foreground.

"The world becomes an apparently infinite, yet possibly finite, card game. Image combinations, permutations, comprise the world game."

—Jim Morrison

"across planes of consciousness,
we have to live with the
paradox that opposite things
can be simultaneously true."
~Ram Dass

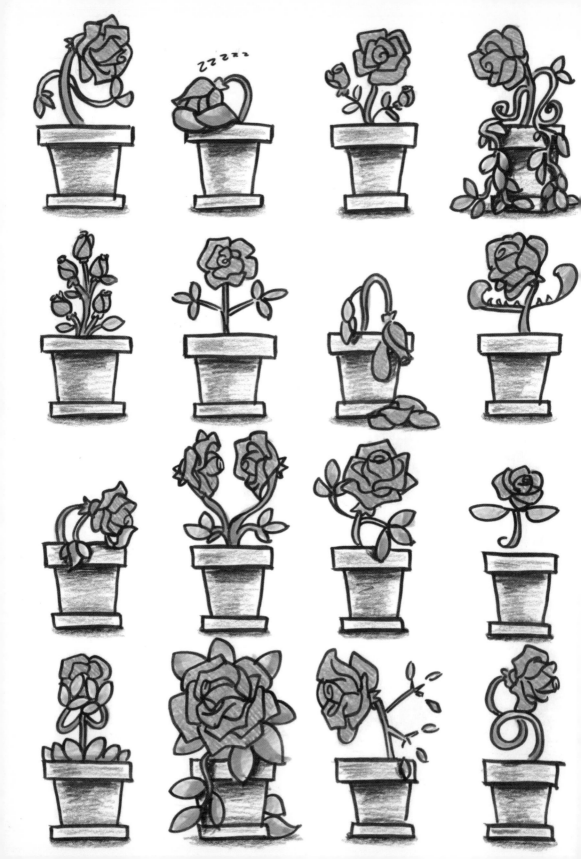

Character Dare

Creating a character is like getting to know a new
part of yourself, allowing part of your personality
to speak for itself as an alter ego.

A good character is rooted in YOUR character—
your mental and moral qualities. Like a plant clipping,
it then takes on an independent life of its own.

I DARE YOU TO CHARACTERIZE YOU!

Develop and draw an original character based on a side-interest of yours.
What things are you passionate about? Curious about? Intrigued by?

Chose which passion you're using as inspiration. Brainstorm images, words, objects, quirks, and settings representing this interest.

Invite your mind to create a character that personifies this part of your personality, this thing you love. Give it a face. Personify it.

Now sketch your alter ego doing the thing they are passionate about, in a suitable setting. Try to capture motion and emotion.

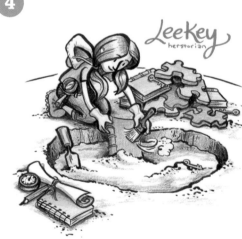

Let the image come alive in your Mind's Eye. What other props can you add to their world and costume? What is their name?

I DOUBLE DARE YOU TO BUILD CHARACTER!

Further expand on your character's world by creating a friend, foe, frenemy, mentor, or sidekick to interact with your alter ego. Do they have siblings or family? Does someone get in the way of them pursuing their passion? Name them.

"Don't just be yourself. Be all of your selves."

—Joss Whedon

"The first [friend] is the alter ego, the man who first reveals to you that you are not alone in the world by turning out to share all your most secret delights."
—C.S. Lewis

Darker Dare

All this inner exploration can stir up a lot of feelings and thoughts. The negative ones can consume us if we let them, so we must be mindful and notice our patterns.

We must shine a light into our inner darkness to prevent sadness, anger, anxiety, grief, shame, envy, guilt, frustration, and jealousy from festering.

I DARE YOU TO DRAW OUT DARKNESS!

Draw a silhouette self-portrait that illustrates a recent experience with a negative emotion. Where in your body did you feel it? What triggered it?

1

Think about a recent negative emotional experience. Reflect on it. Act it out in your head. Channel it. What emotion is it? Label it.

2

Sketch out the body language to capture this emotion, working in loose sweeping lines. You can twist, bend, or stretch your silhouette.

3

You can do just the silhouette or add more designs on top of/interacting with your silhouette to further illustrate your feeling.

4

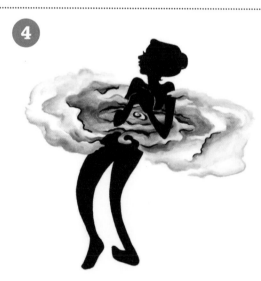

Shade in your silhouette with black ink, and shade other designs with color. When you're done with your drawing, let the emotion go.

TIP *Don't focus on making the silhouette look like you specifically. Make it more universal and simplified rather than realistic. Don't be scared to really exaggerate the form for the sake of expressing the emotion. Be dramatic! Use your artistic license.*

I DOUBLE DARE YOU TO DISPEL DARKNESS!

Make another silhouette portrait . . . this time illustrating a positive feeling. How do you feel when you return to happiness after being sad? Inside your silhouette, draw a bright vision of what brings you joy, your happy place, or other visualization of your lightness.

"Keep
painting
your
demons."

—Jack Beal

"Put light against light—you have nothing. Put dark against dark—you have nothing. It's the contrast of light and dark that each give the other one meaning."
—Bob Ross

Inner Critic Dare

Our inner critic puts us down, picks apart our efforts,
doubts our worth, and repeats every negative
criticism ever said to us.

This is why you must change the conversation
by giving yourself pep talks, reminding yourself
of your motivations for making art.

I DARE YOU TO HOLLABACK!

We might not be able to stop our critic from shouting put downs,
but we can shout over it louder with positive self talk.

1

First list your put downs as critical "you"
statements . . . and your pep talks as
encouraging "I" statements.

2

Then fill your page with speech bubbles
containing your put downs.
Using lighter drawing tools for this.

3

Speak over/draw over with speech bubbles
containing your pep talks, this time using
darker drawing tools.

4

Add shading as desired to bring out
your pep talk speech bubbles and pull
together the drawing.

I DOUBLE DARE YOU TO DEFY THE CRITICS!

Think about a past mistake, failure, or embarrassment that your inner critic would love. One you bounced back from. What lesson did you learn? Did it make you stronger, humbler, braver, etc.? Write out your positive takeaway in a pretty font.

"Eat the pain. Send it back into the void as Love."

— Amanda Palmer

"It's amazing how many things you can do when you're just pretending."
—Kim Gordon

Reflection Dare

Building confidence and bravery requires that you see
yourself clearly. So grab a mirror and get ready
for some honest reflection!

We will explore our strengths and weaknesses.
This type of reflection helps us accept, celebrate,
and trust who we are.

I DARE YOU TO DEFINE A STRENGTH!

Create a dictionary listing that defines a personal strength, accompanied by a self-portrait in the style of your choosing. Under what positive word in the dictionary would you see yourself being listed?

1 First draw your self-portrait in pencil, using a mirror for visual reference. Go over your lines with a colored marker, and add shading with colored pencil.

2 When drawing from a hand mirror, I like to use masking or painter's tape to secure it to the wall as I draw. Also, make sure you are using a mirror large enough so you can see your whole face at once. Hold still!

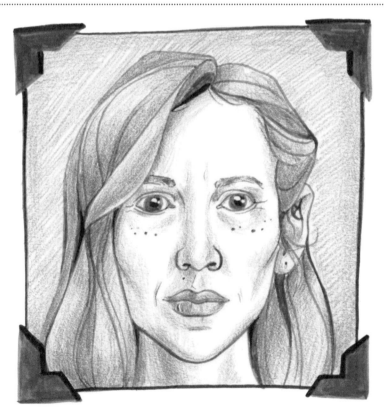

FOCUS [foh-kuh s]

1. To concentrate: to focus one's attention. 2. To direct one's attention or efforts. 3. Laura Lee Gulledge.

I DOUBLE DARE YOU TO REFLECT A FLAW!

What self-perceived physical or emotional flaw do you see when you look in the mirror? Or perhaps a feature you used to be self-conscious about? Draw a caricature of yourself that exaggerates it. Poke fun at your imperfections.

"You use a glass mirror to see your face; you use works of art to see your soul."

— George Bernard Shaw

"Sincerity
is the surest
road to confidence."
-David Lloyd George

Family Dare

Who else cheers us on and is invested in our success?
Our family. They offer us support and a reason beyond
ourself to create the work we do.

We all have two families: the biological or adoptive
family, and the world family of friends and mentors
you choose yourself.

I DARE YOU TO CLIMB THE FAMILY TREE!

Tell a story from your biological or adoptive family tree! Perhaps a similarity you share with an ancestor, the story of your name, an immigration story, love story, ghost story, strange family coincidence, or old family legend.

1 Write your short story on separate paper, editing it down to a few blocks of text. Draw a close-up of a branch of a tree, containing perhaps three to eight leaves. Outline them in silhouette. These leaves will be the panels for your story!

2 Fill in the leaves with your text along with a few images to illustrate your story, going clockwise around the page. The images you include could be portraits or people, maps of locations, symbols, designs, or props mentioned in your story.

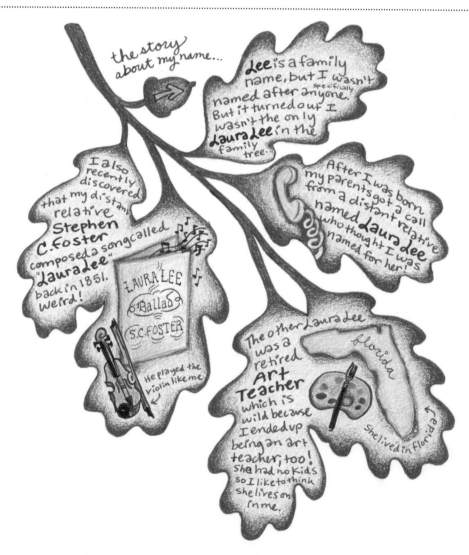

TIP *If unsure what story to tell, reach out to an older relative to talk to about this sketchbook dare and see if they have any ideas! Ask questions about their childhood and about yours. They often will reveal stories you didn't know!*

I DOUBLE DARE YOU TO SCOOP UP LOVE!

Who outside your biological family is in your support system? Make a list.
Draw all your various stand-alone friends and friend-groups as a scoops of ice cream
in one big world-family cone or bowl. Or as various toppings.

"If you want to change the world go home and love your family."

—Mother Teresa

"Each friend represents a world in us, a world possibly not born until they arrive and it is only by this meeting that a new world is born." —Anais Nin

You support each other in your individual creative efforts, sometimes collaborating on projects together.

Artners help each other stay inspired, reach goals, stay healthy, solve problems, make connections, and remember to have fun!

I DARE YOU TO ARTNER IN SILENCE!

Make a pair of silent drawings with an Artner, having a nonverbal visual conversation.

Ask a friend out on an Artner date! Sit across from each other with a blank page and some art materials in the middle. Enter a period of silence.

You pick up a drawing tool and make a shape, line, splotch of color, etc. on the page. When done, put the drawing tool down.

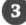

Your Artner then picks up a drawing tool of their choice and adds something to the page, putting down the tool when done.

 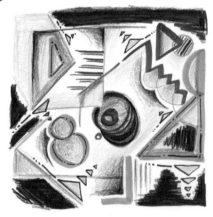

Take turns repeating this process until it feels "done." (That is, when the page starts to feel full and the pace slows down.) Discuss! Try again.

TIP *If you like something your partner draws, try mimicking it or building off it! Repetition creates harmony and rhythm. Stick to abstract designs, lines, and shapes rather than striving for realism. No talking is allowed, but gesturing and miming is permitted.*

I DOUBLE DARE YOU TO SHARE INK!

Using a pencil, you and your Artner each draw a cartoon-style portrait of a mutual friend with a blank speech bubble, above his or her head. Then swap papers and ink over the other's pencil lines. Fill in the speech bubble with a "catchphrase" your friend says often.

"Find a group of people who challenge and inspire you, spend a lot of time with them, and it will change your life."

—Amy Poehler

"I have seen further by standing on the shoulders of giants."
—Isaac Newton

You are going to play games using your wits
and your pens! These can be completed alone
but are more fun in a group.

Multiple creators make a single drawing either
by passing it around in a circle or taking turns
working on it at a single station.

I DARE YOU TO PLAY ON WORDS!

First choose a long word to use as the basis of your drawing, something nine to twelve letters. (Perhaps the street you are on?)

1

Write your chosen word so it snakes around the page, making an oval. Leave space between each letter. Vary repeating letters.

2

The first player turns the first letter into . . . something! As a group, pick a simple yet flexible theme like people, creatures, food, etc. While completing your letter, don't crowd the space for the next letter!

3

Pass the paper to the next player, who turns the next letter into something. And then so on and so on. Welcome whimsy, play, and silliness. Encourage each other.

4

The paper is passed around until each letter is transformed, making it hard to see the original word at all!

I DOUBLE DARE YOU TO PLAY ON WINDOWS!

First draw the side of an city apartment building with lots of windows.
Then invite participants to add little characters and scenes within each window.
Perhaps even pick a theme for who or what lives there!

"My work is a game, a very serious game."

—M.C. Escher

"Play is
our brain's
favorite way
of learning."
-Diane Ackerman

Break Through Dare

Trouble breaking through the 80% wall? That's when
you're almost done but you get stuck or bored,
often abandoning your project for a new idea.

When stuck you need a literal breakthrough.
Access inspiration by relaxing your brain so you can hear
the big crazy idea in the back of your head.

I DARE YOU TO BREAK EXPECTATIONS!

Practice risk-taking by drawing something you don't like.
Disdain helps quiet our fears and expectations of what our art "should" be.

1

Draw a picture of a food you don't like. It could
be a close up of one or a collection of many.
Use any media and style.

2

When you're about 80% done, stop and take
a break. Take a walk. Get out of your head by
getting into your body. Calm and clear your mind

3

Return and look at your image fresh. Resee it as
pure visual data by looking at it from far away,
upside down, in a mirror, a photo,
or by squinting your eyes.

4

Now take a visual risk with it! Think, "This
drawing is a lost cause! Well, since it's ruined
anyway, I might as well try _____," and see
what idea pops in your head.

TIP *What does the art "need"? Take risk by adding a pop of color, incorporating a new medium, changing the background, adding a silhouette, drawing over/erasing what you don't like, adding text or a speech bubble, or spattering paint on it.*

I DOUBLE DARE YOU TO BREAK THE CYCLE!

Pull out some old sketches, drawings, or other artworks that are unfinished.
Combine them, alter them, draw on them to create a new finished piece!
Allow your repurposed artwork to surprise you. Done is better than perfect.

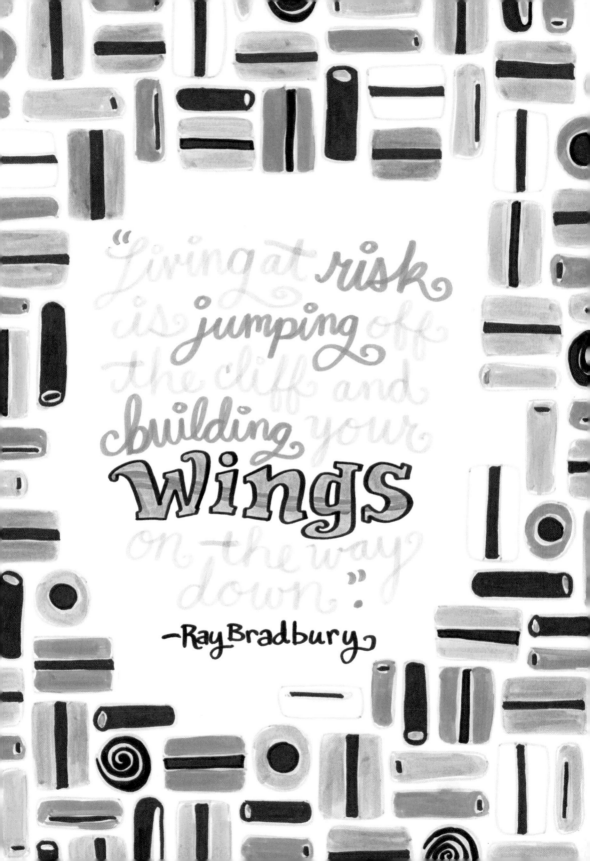

"Living at risk is jumping off the cliff and building your **wings** on the way down."

—Ray Bradbury

"Fear is what blocks an artist. The fear of not being good enough. The fear of not finishing."
—Julia Cameron

Unwind Dare

Want to loosen up your art style? Start with loosening up your drawing tools: your hands! Unwind then through repetition, speed, and play.

Speed in particular helps because you don't have time to doubt yourself! The urgency forces you to draw lines confidently and decisively.

I DARE YOU TO UNWIND YOUR HANDS!

Draw something multiple times in a row, each time cutting your work-time in half.
I'd recommend drawing a small family heirloom or perhaps something small and detailed.

17 minutes

Grab your object, a timer, ink pens, and a pencil.
Lightly sketch circles on your page to mark the
areas where your drawings will go.

8 minutes

Draw your chosen object in the first circle. Time
how long it takes you at your natural pace. I used
a brush pen to outline and fine pen for details.

4 minutes

Now how long did that take you? Cut that time
in half. Set a timer, and draw your object again
in half time. Go, go, go!

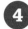

2 minutes

Now cut the time in half again! Set a timer and
draw your object in half the previous time.
Compare! You can continue counting down
if you wish.

TIP *Pick an object with interesting details and textures so you have lots of visual data to play with. Try to capture as many details as possible in your first drawing so you can notice which details change or disappear as you draw faster.*

I DOUBLE DARE YOU TO UNWIND YOUR FINGERS!

Loosen up by drawing with your fingerprints! Make a self-portrait using just an ink pad and your fingertips. Your result will be a little "out of focus."

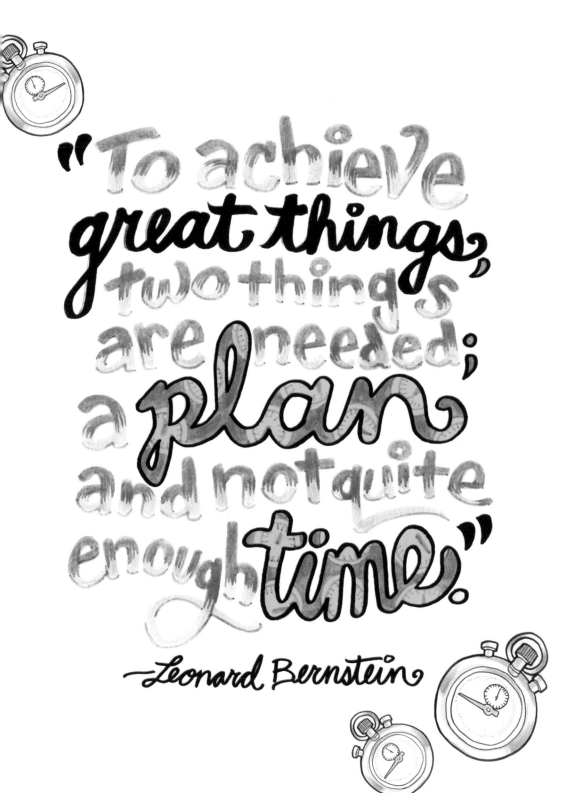

"To achieve great things, two things are needed; a plan and not quite enough time."

—Leonard Bernstein

"Remember that sometimes
not getting what you
want is a wonderful
stroke of luck."
—Dalai Lama XIV

Our stories and visions are gifts we've been given
that we can, in turn, share with the world.
They're our sacred offering.

Through telling our stories, we model to others
vulnerability, resiliency, bravery, compassion, and how
to be a human.

I DARE YOU TO OFFER STORIES!

Draw your nondominant hand holding out a small collection of sacred objects, souvenirs, trinkets, good luck charms, or other keepsakes from things you've done.

1 Ideally, take a quick photo of your hand holding your objects to use as visual reference while drawing. Why? Because it's hard to hold your hand perfectly still for that long. And because hands are hard enough to draw as it is!

2 Draw in the center of the page, leaving plenty of space in the background. When done with the drawing, you will fill the background with stories about each artifact. Open up a little! Make it personal!

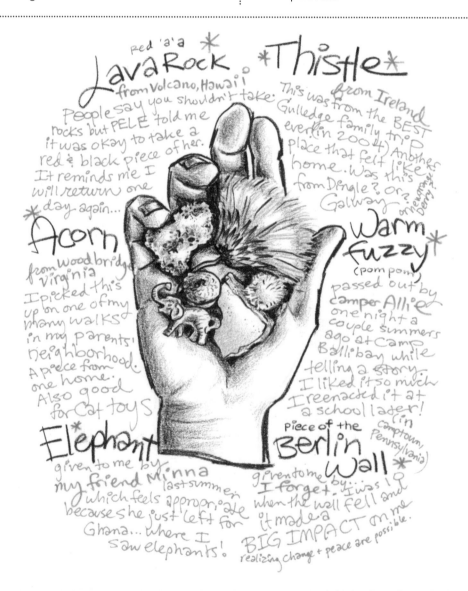

Red 'a'a *
LavaRock ° **∗Thistle∗**
from Volcano, Hawai'i
People say you shouldn't take
rocks but PELE told me
it was okay to take a
red & black piece of her.
It reminds me I
will return one
∗ day again...

This was from Ireland
Gulledge family trip
ever. In 2004. Another
place that felt like
home. Was this
from Dingle? Or?
Galway?

Acorn
from Woodbridge
Virginia
I picked this
up on one of my
many walks
in my parents'
neighborhood.
A piece from
one home.
Also good
for cat toys

Warm fuzzy∗
(pompom)
passed out by
camper Allie
one night a
couple summers
ago at Camp
Ballibay while
telling a story.
I liked it so much
I reenacted it at
a school later! (in
Camptown,
Pennsylvania)

∗Elephant∗
given to me by Minna
my friend last summer
which feels appropriate
because she just left for
Ghana... where I
saw elephants!

Piece of the
Berlin Wall ∗
given to me by...
I forget. I was 19
when the wall fell and
it made a
BIG IMPACT on me
realizing change + peace are possible.

I DOUBLE DARE YOU TO OFFER SECRETS!

Get extra personal through journaling. Write out what you'd like to get off your chest: a secret, confession, fear, personal truth, worry, etc.—perhaps upside down. Then black-out, distort, censor, or conceal parts of it.

"It is the love of something, having so much love of something... that all can be done with the overflow is to create." -Clarissa Pinkola Estés

Hero Dare

After all this inner exploration, we will now look outward to who inspired you to embark on this creative journey in the first place: your heroes.

Our heroes (or historical mentors) give us strength, wisdom, solace, and footsteps to follow in, because, like them, we're also on a hero's journey.

I DARE YOU TO FACE YOUR HERO!

Draw a portrait of a hero who has helped inspire you or greatly influenced you,
someone whose life and/or work you've loved for a long time.
They could be living or dead.

1 Think about why this person is important
to you. What did they teach you?
How exactly did they influence you?
Imaging hanging out with this person.
Do some research into them to discover
things about their journey you didn't
already know.

2 Pick the first person that rises to the
surface, and find a photo of them
to use as visual reference. Focus on their
head and shoulders rather than the whole
body. Add a note to accompany your
image, thanking them for what they've
inspired in you.

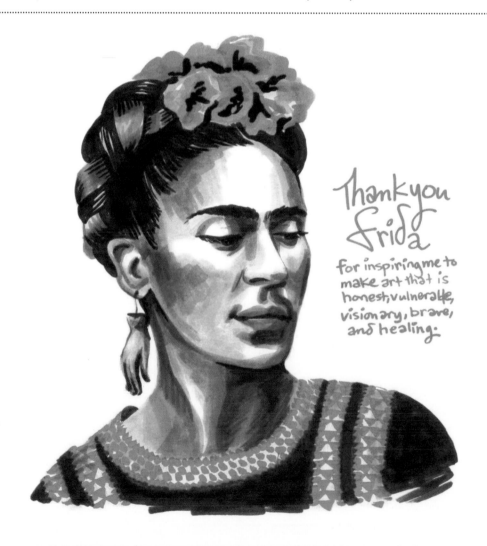

Thankyou
frida
for inspiring me to
make art that is
honest,vulnerable,
visionary, brave,
and healing.

TIP *Feel free to personalize your image rather than trying to copy your visual reference image perfectly. You can even combine elements from multiple images, change colors around, or add extra designs. Try to capture your hero's style and spirit.*

I DOUBLE DARE YOU TO WALK THEIR PATH!

Copy an artwork made by a hero to try on their style, see through their eyes,
walk in their footsteps. Copy a whole work or focus on a close-up study.

Note: Copying an old master is another of da Vinci's sketchbook practices, too!

"A true artist is not one who is inspired, but one who inspires others."

—Salvador Dalí

"My heroes are the ones who survived doing it wrong, who made mistakes, but recovered from them."
—Bono

Journey Dare

For our final dare, we will reflect on the journey that has
brought you here . . . and what's next on your path
of self-discovery and evolution.

Such mindfulness helps us navigate the journey more
intentionally. It's our choices that carve our path and
ultimately become our life's story.

I DARE YOU TO LOOK INTO THE FUTURE!

Draw a self-portrait of yourself on or in a mode of transportation that's taking you into your future! Where do you wish your journey to take you after completing this book? You might not know the final destination, but you can pick your ride!

1 What vessel or vehicle would best symbolize the next leg of your journey? Be creative! It could be mechanical or animal, everyday or fantastical, by air or by sea, in space or underground, on skates or on skis, etc. Brainstorm some ideas.

2 When you have your idea, sketch a few thumbnails to help figure out your layout. Try to give it a feeling of motion and movement, as you're beginning a trek, after all. Draw in pencil, then ink and shade with marker or colored pencil.

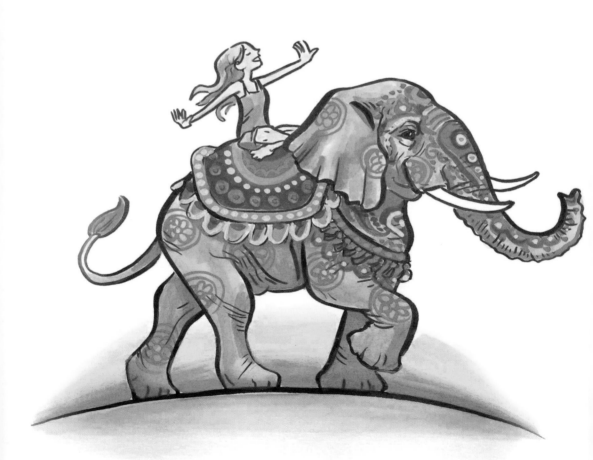

TIP *Show how you are feeling about the future in how you draw your self-portrait through your body language and facial expression. Are you the passenger or the driver? Are you looking ahead or bidding the viewer farewell?*

I DOUBLE DARE YOU TO DRAW YOUR JOURNEY!

Draw a board game or a maze that represents your life's journey up to this point. Perhaps you had obstacles or shortcuts along the way. Perhaps there are multiple paths, starting points, or destinations. It could be playable or not, funny or serious.

"If you're any kind of artist, you make a miraculous journey, and you come home and make statements in shapes and colors of where you were." —Romare Bearden

Suggested Reading

- *Drawing on the Right Side of the Brain* by Betty Edwards
- *The Artist's Way* by Julia Cameron
- *What It Is* by Lynda Barry

- *Art & Fear* by David Bayles and Ted Orland
- *The Highly Sensitive Person* by Elaine N. Aron
- *The Art of Asking* by Amanda Palmer

- *Big Magic* by Elizabeth Gilbert
- *The Art Guys* by Lynn M. Herbert
- *Choice Theory* by William Glasser, MD

- *No Mud, No Lotus* by Thich Nhat Hanh
- *The Four Shields* by Steven Foster and Meredith Little
- *The Four Agreements* by Don Miguel Ruiz and Janet Mills

Online Resources

The Sketchbook Project

sketchbookproject.com

This is the world's largest collection of sketchbooks! You can take part in their yearly theme, submit your sketchbook, and visit their library.

Creative Sprint

www.creativesprint.co

This is a monthly challenge of making and sharing, which you can take part in with others via social media.

Doodlers Anonymous

www.doodlersanonymous.com

This is an online community and resource for drawing enthusiasts! You can share your work and find inspiration.

Artners!

artnerproject.tumblr.com

Want to learn more about Artnership and how you can connect with an Artner? Here's our little corner of the internet.

Sketchnote Army

sketchnotearmy.com

Learn how to incorporate your love of sketching into your note-taking process to improve learning and communication!